THE SKETCHBOOK OF A GENTLEMAN

LONDON · ROBIN LUCAS

COLLECTIVE SHORTS
by NHP PUBLISHING

For
H & T

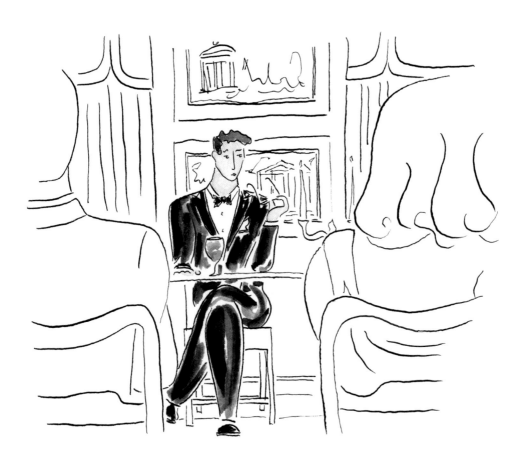

The Sketchbook of a Gentleman – London

London is an extraordinary city, full of extraordinary characters. Observation is key to getting the most of a place; it is very easy to run from one place to another and never look at where you are. This book is drawn through the eyes of Edward, a modern gentleman, and his perspective on London and the activities he enjoys there. The aim was to create a character embodying a man of tradition but with both feet placed firmly in the 21st century. The illustrations in this book are all based on reality, and trace real events and real places in the capital.

Images have long been the primary way of conveying information: they allow the viewer to come to their own conclusions, are cross-cultural, and break language barriers. Illustration is enjoying a renaissance, it can perform a function that photography can never achieve, and that is the element of fantasy and suggestion. It allows the viewer's imagination to fill in the gaps and make it their own. The book pulls inspiration from the heyday of illustration in the 1920s and uses that as a base to create an elegant and sophisticated view of contemporary London life.

MONDAY

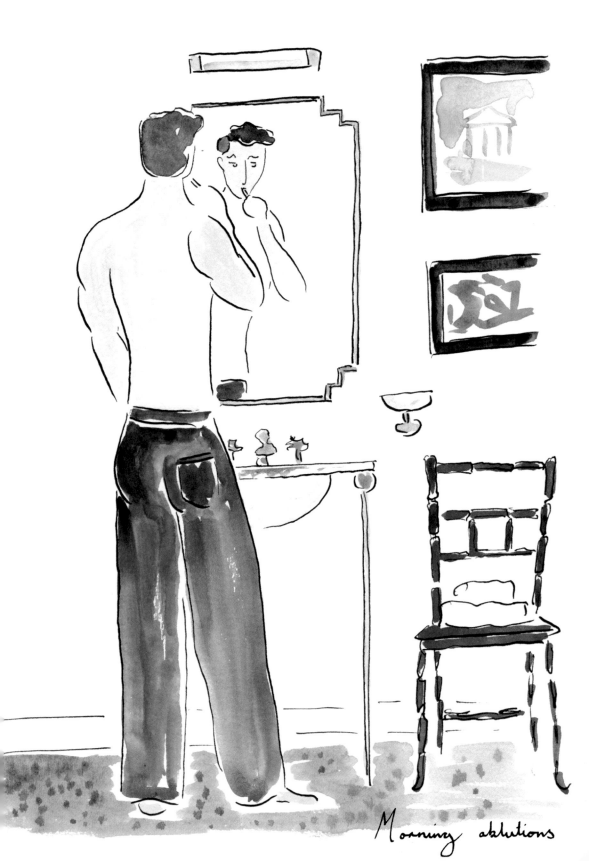

Morning ablutions

From Lutyens to Wren, not a bad place for a pool

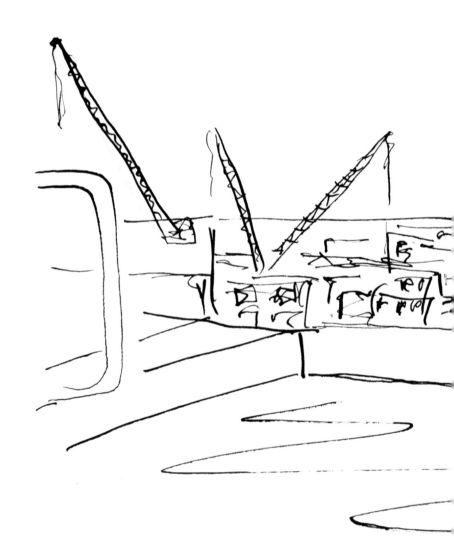

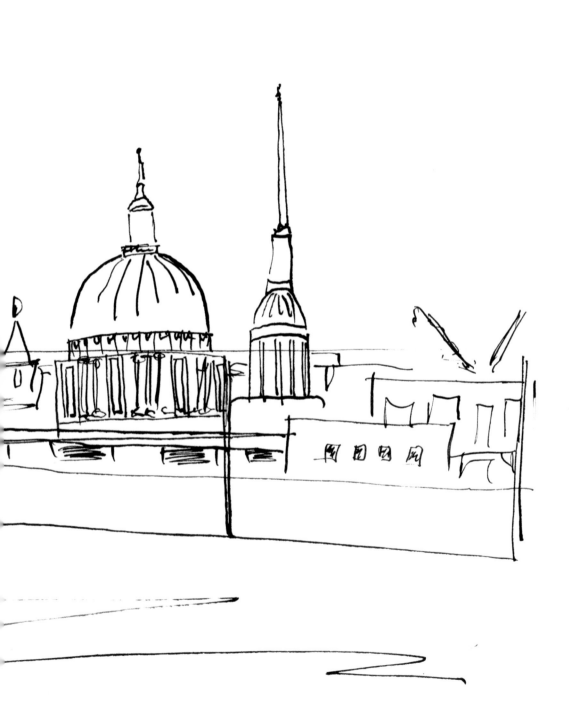

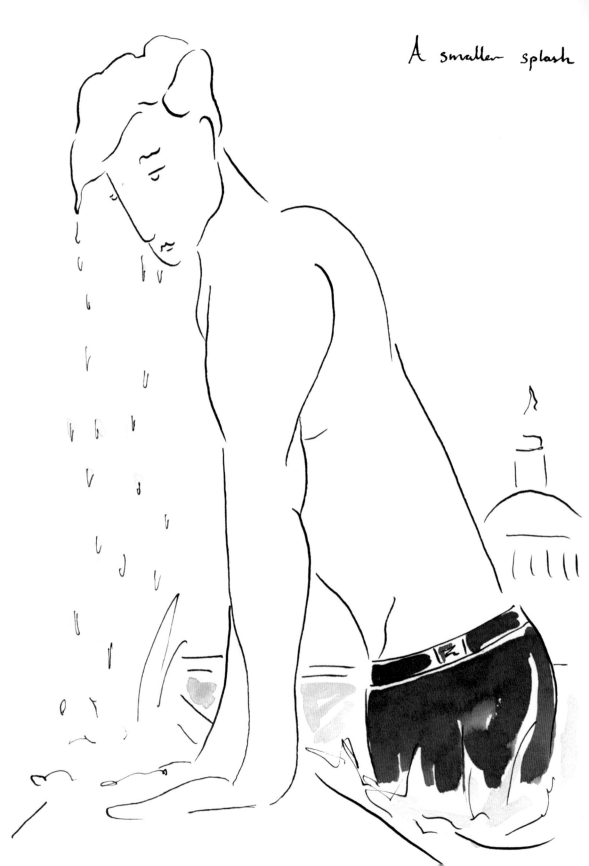

A smaller splash

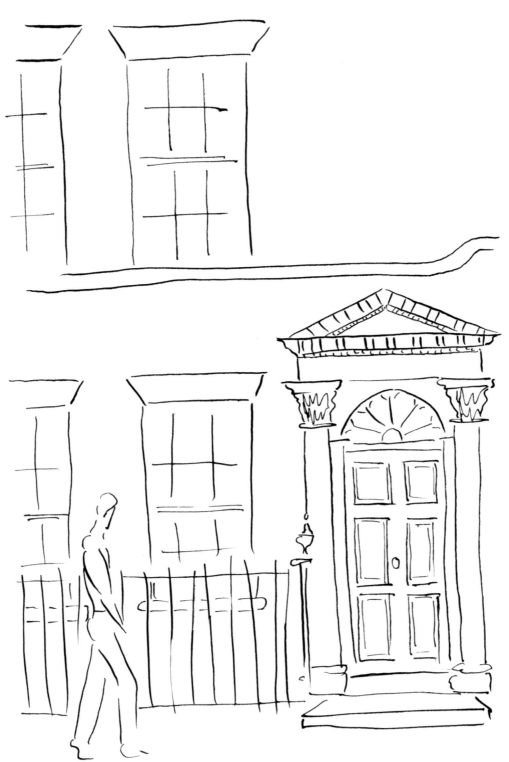

Cutting a dash through Bloomsbury

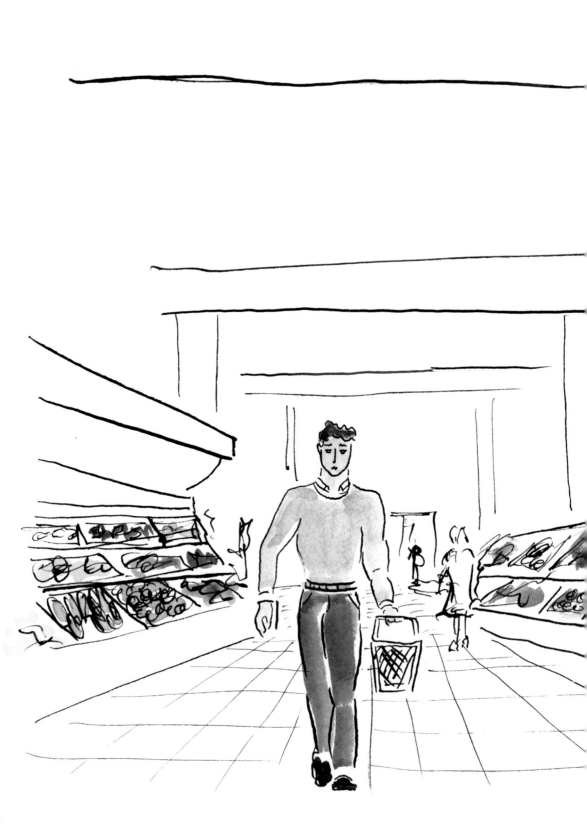

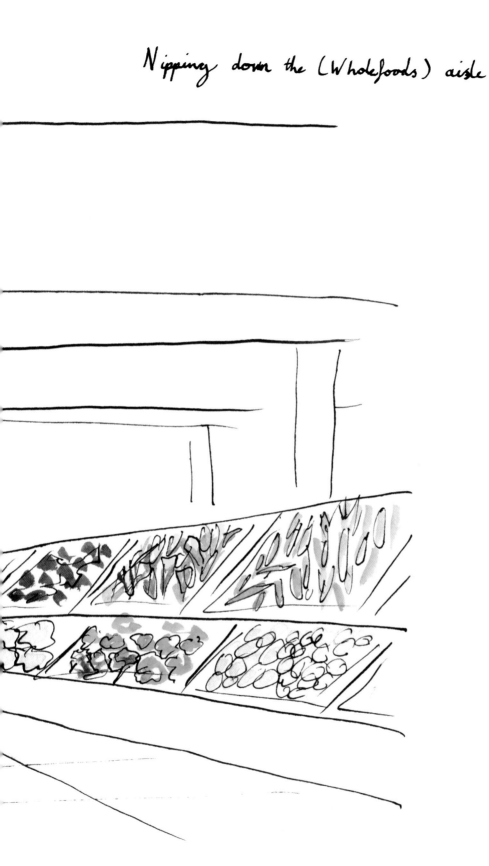

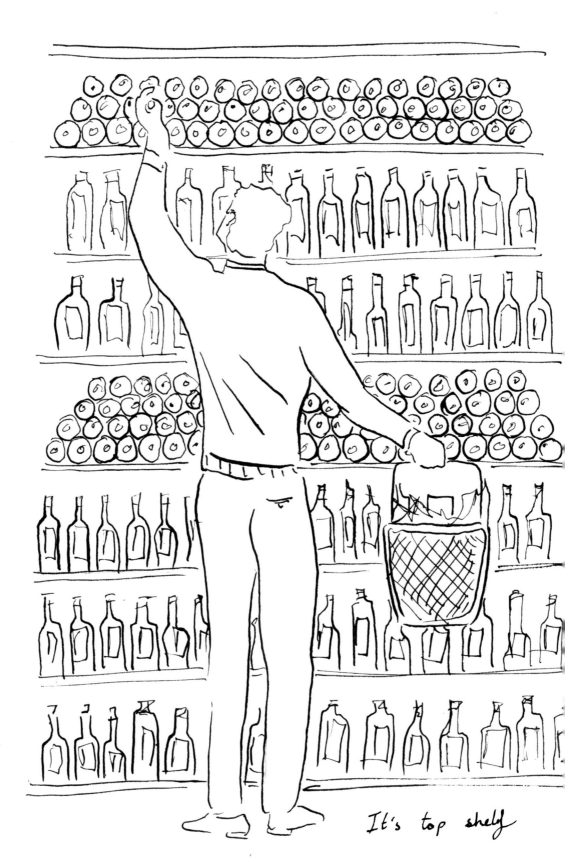

It's top shelf

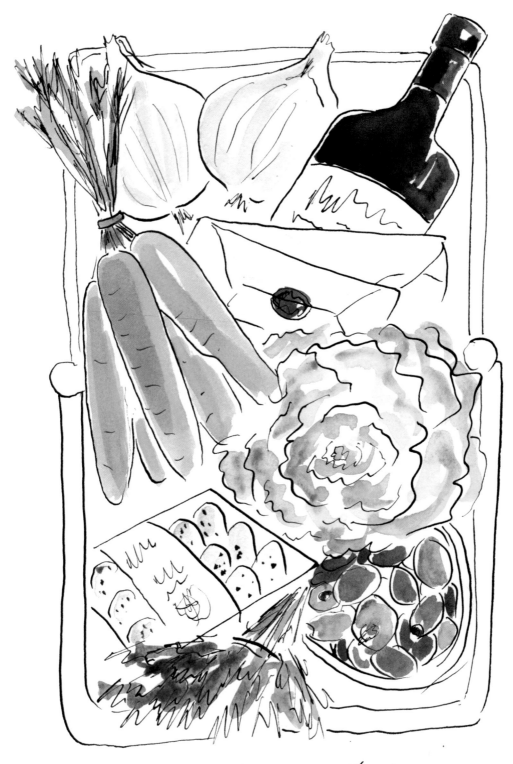

The bare necessities

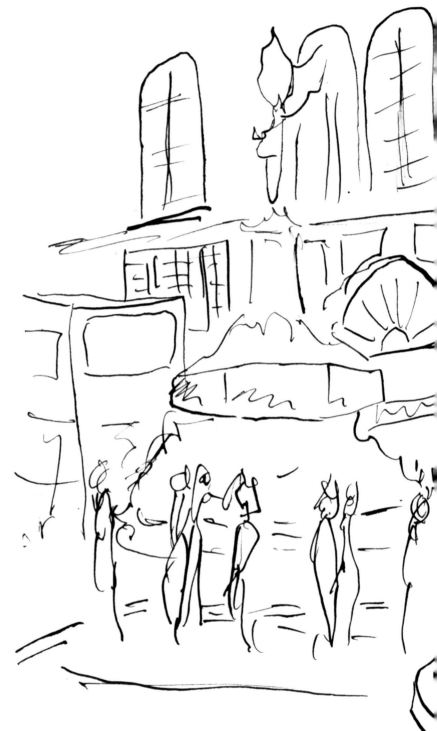

Piccadilly Circus

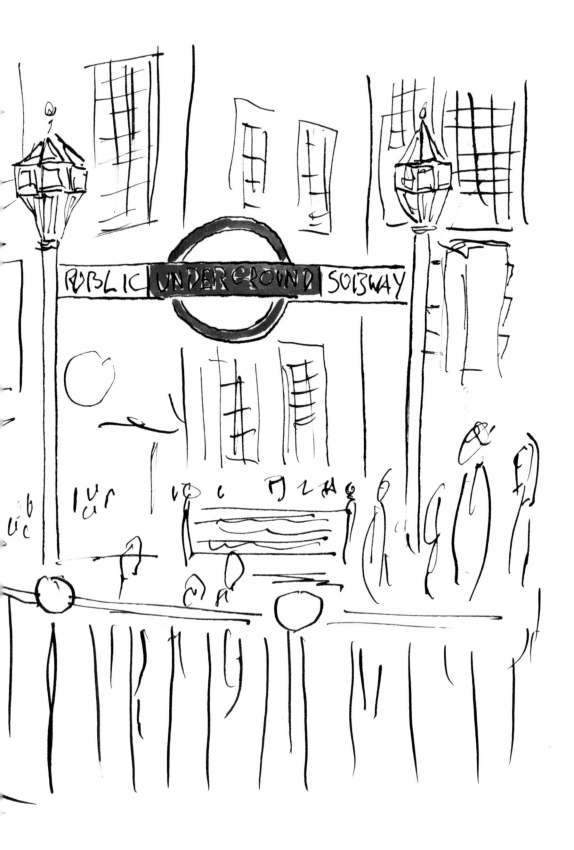

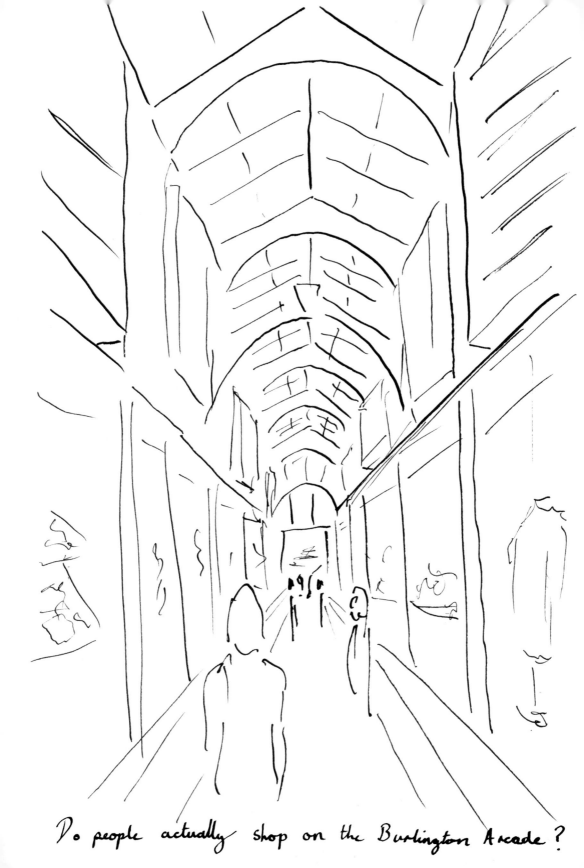

Do people actually shop on the Burlington Arcade?

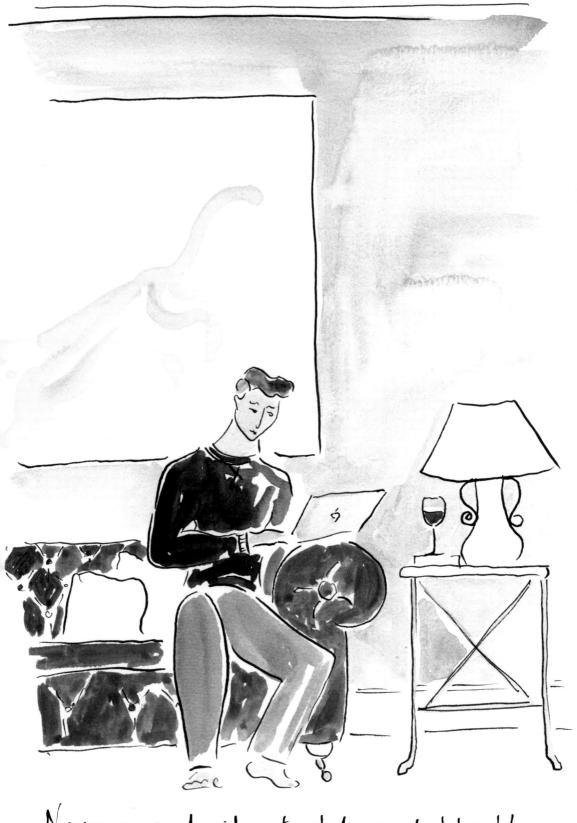

Never a good idea to check emails before bed

TUESDAY

The home of sartorial elegance

HUNTSMAN

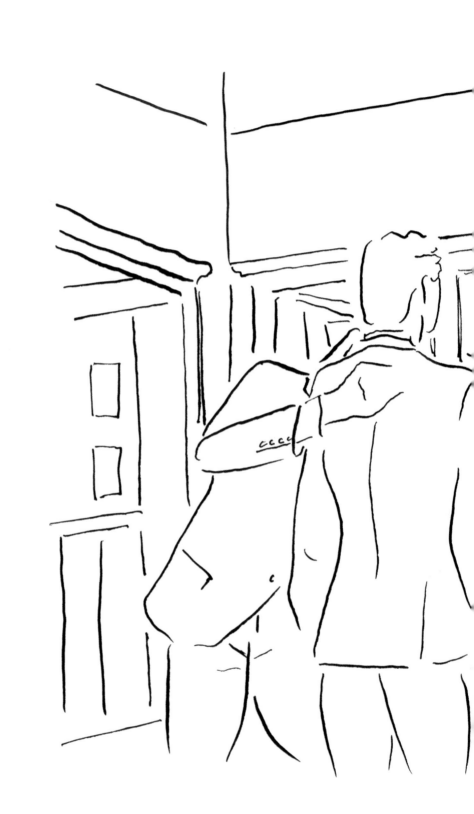

Fit for a king

The cut makes all the difference

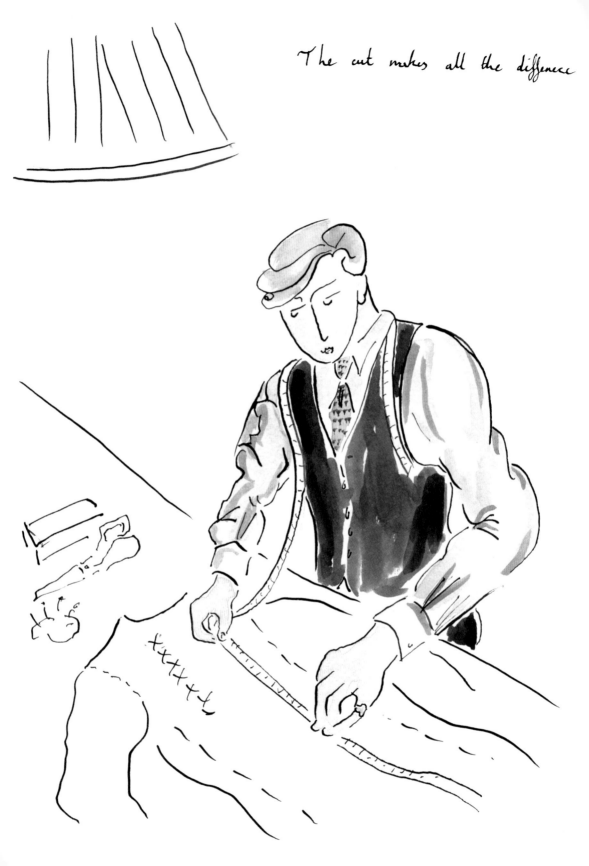

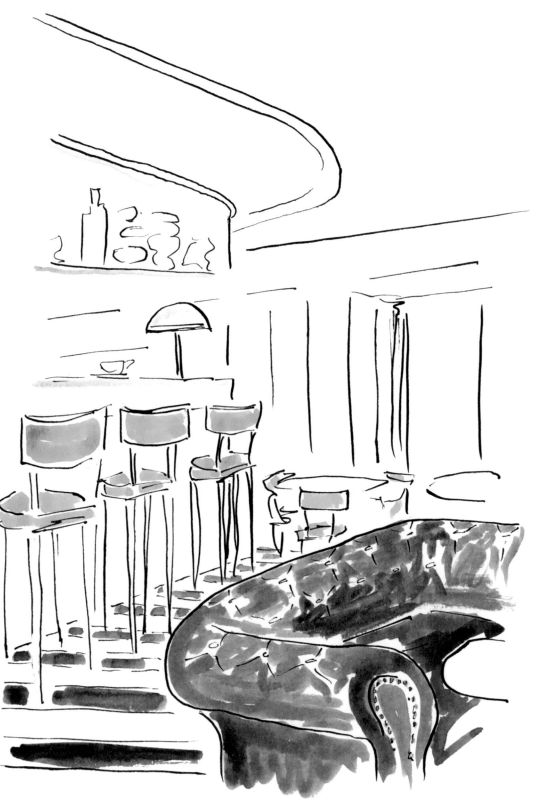

Better than Venice itself, no unsavory smells here!

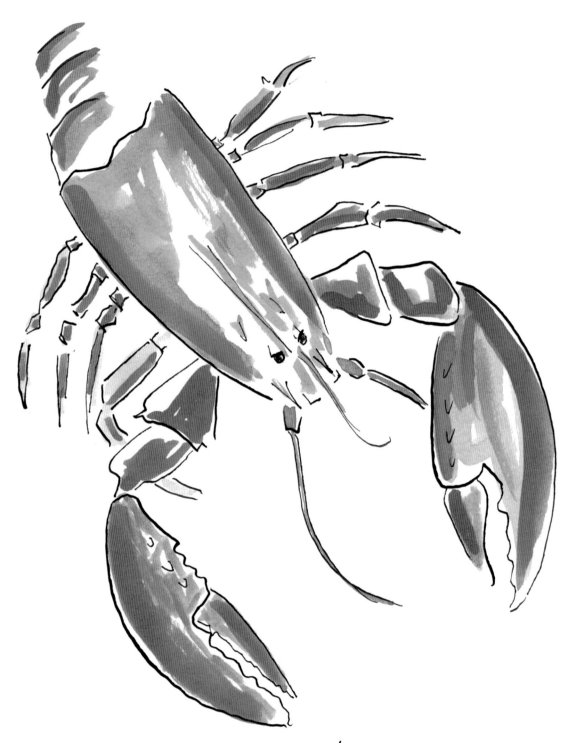

Lobster for lunch?

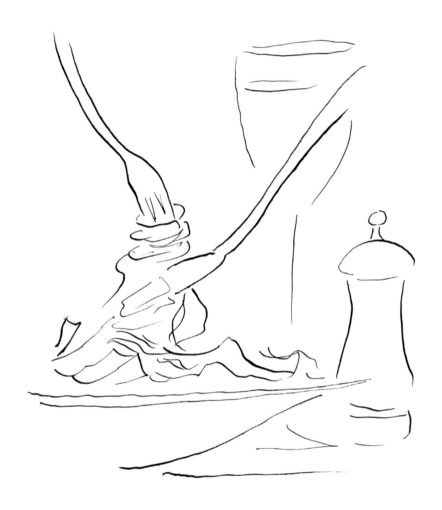

Oh, who cares, it's Tuesday after all

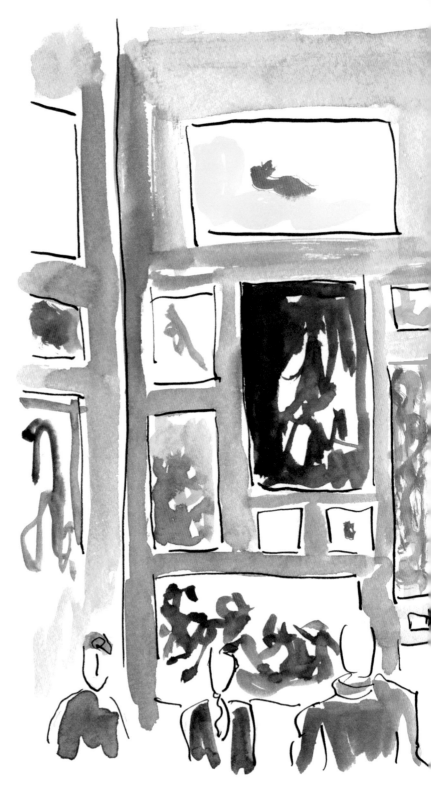

I like to be challenged by the art, not the crowds

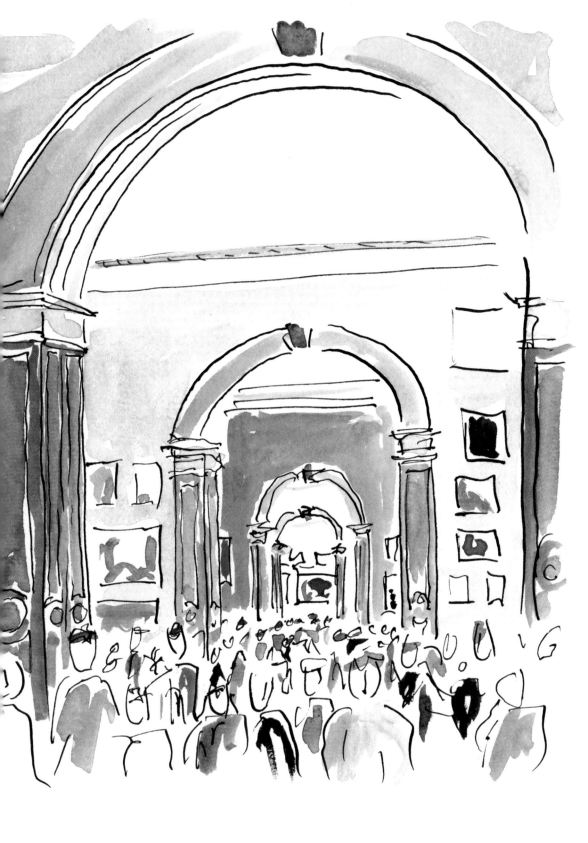

Always look into art, not at it

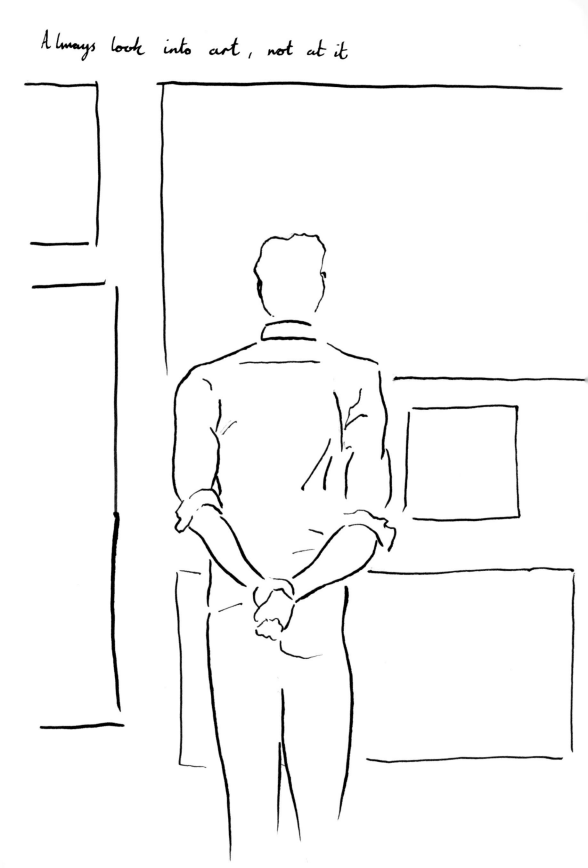

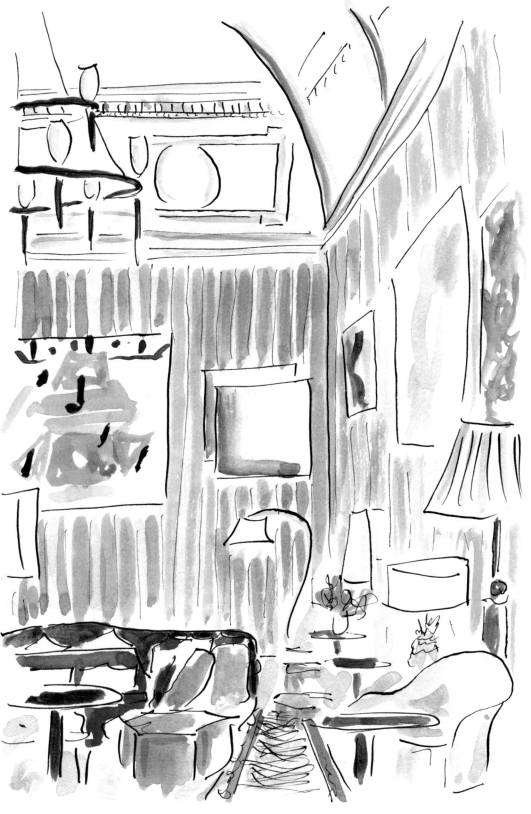

The Academicians' Room, The Royal Academy of Arts

WEDNESDAY

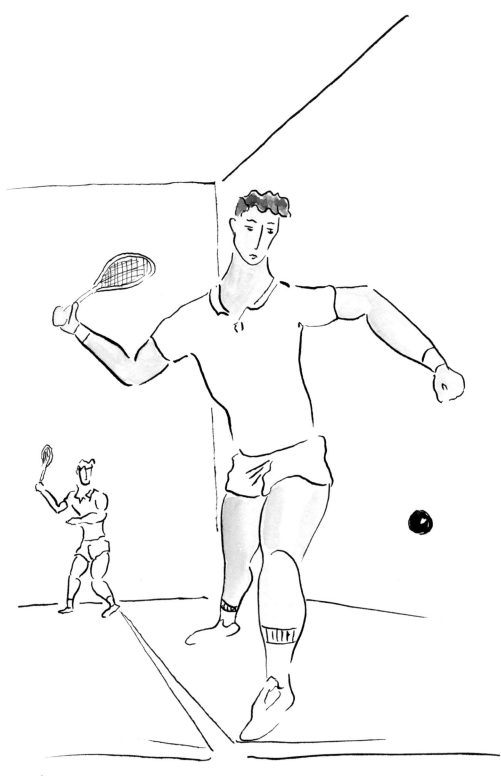

I should have taken advantage of his weak
backhand, but manners maketh man

Game over

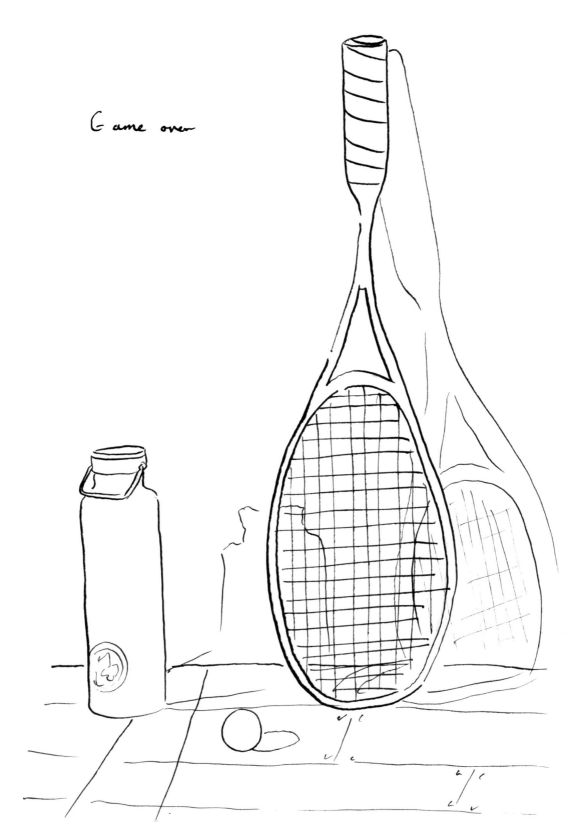

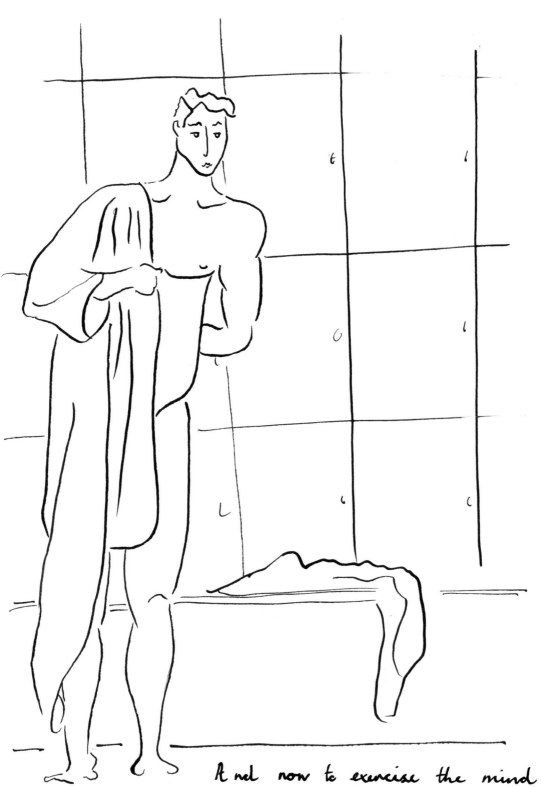

And now to exercise the mind

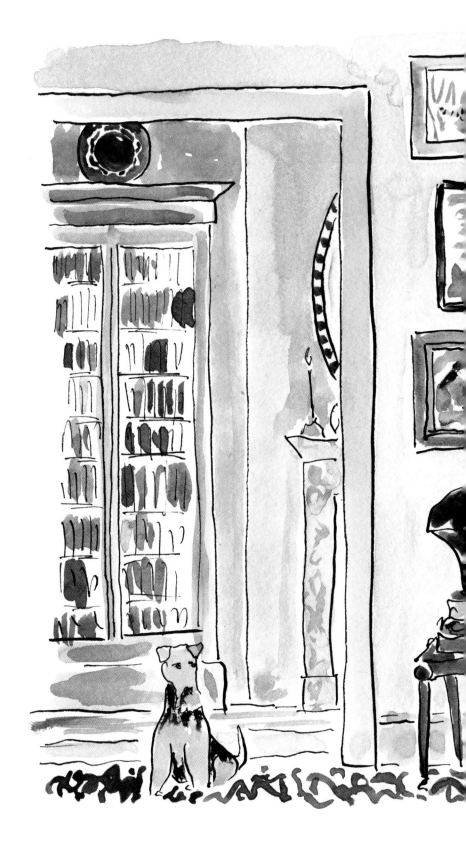

Rarely a negative contribution, he makes a very good study partner

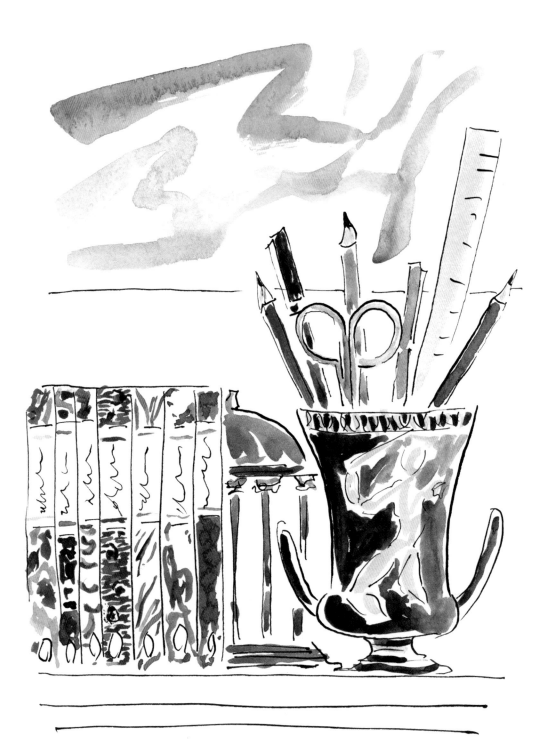

Tools of the trade

No excuse for novelty cufflinks

Thankfully a black cab is more reliable than the weather!

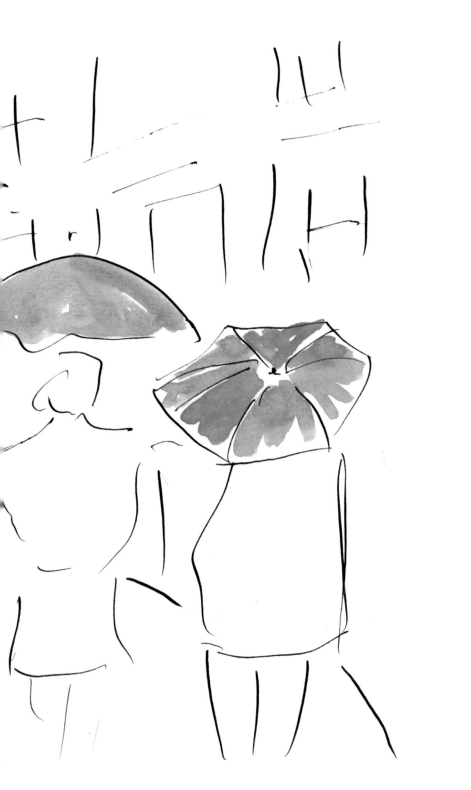

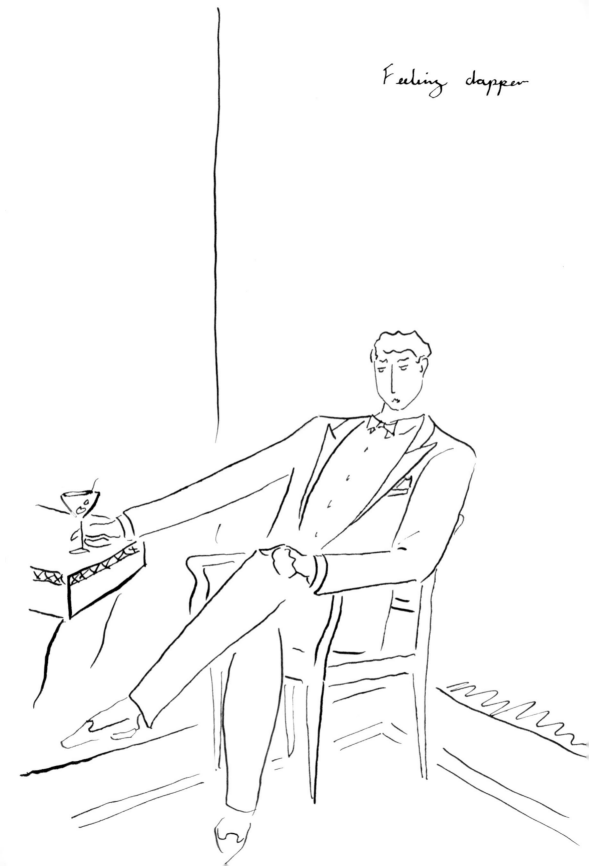

Feeling dapper

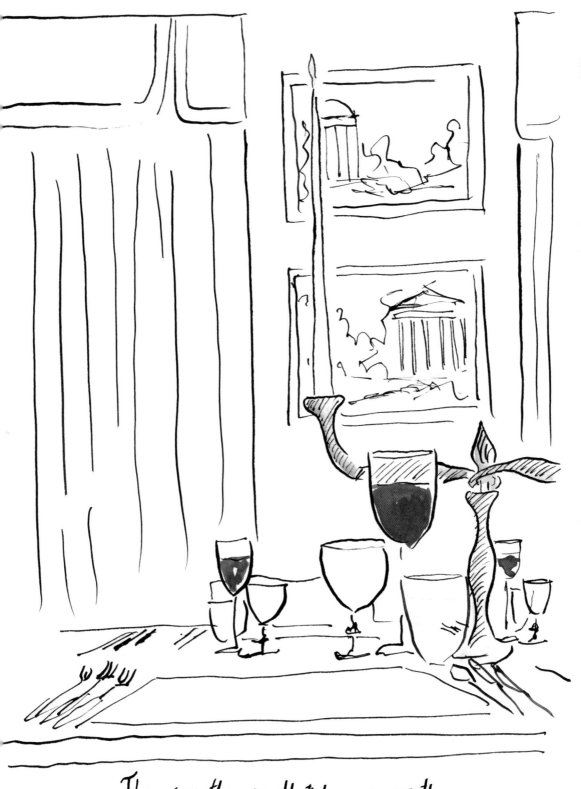

They say the candlesticks are worth
more than the house

Dinner here is always a formal affair

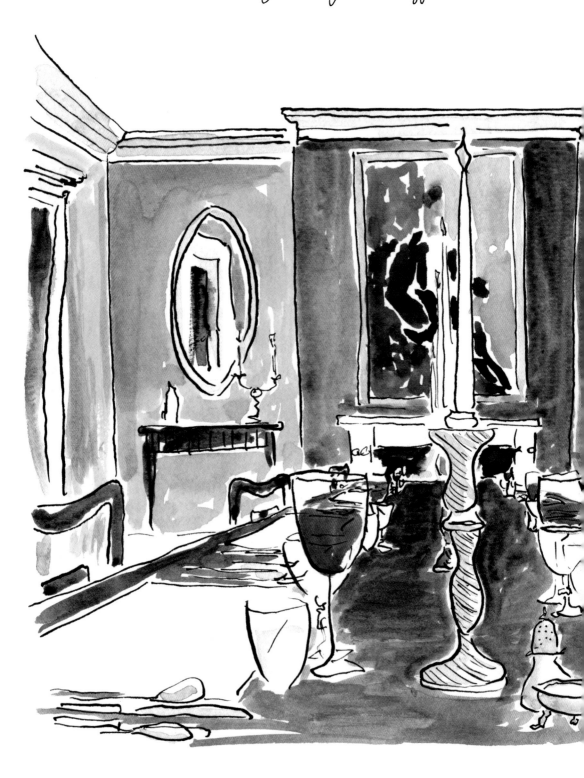

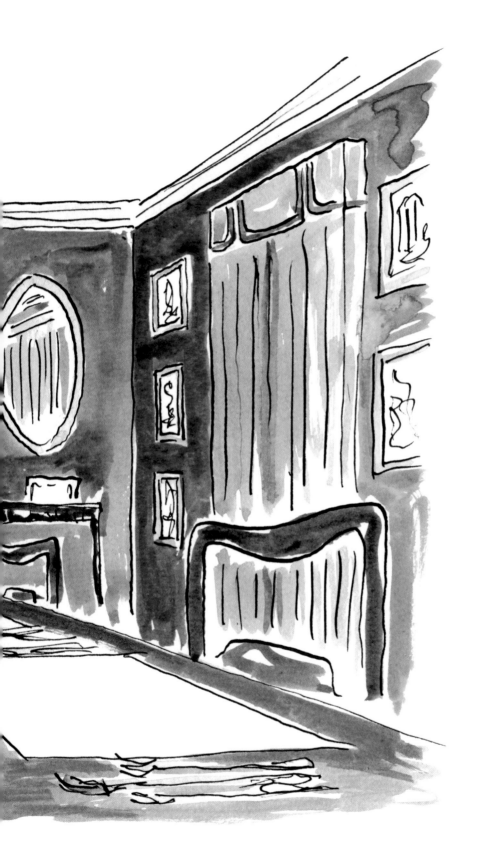

THURSDAY

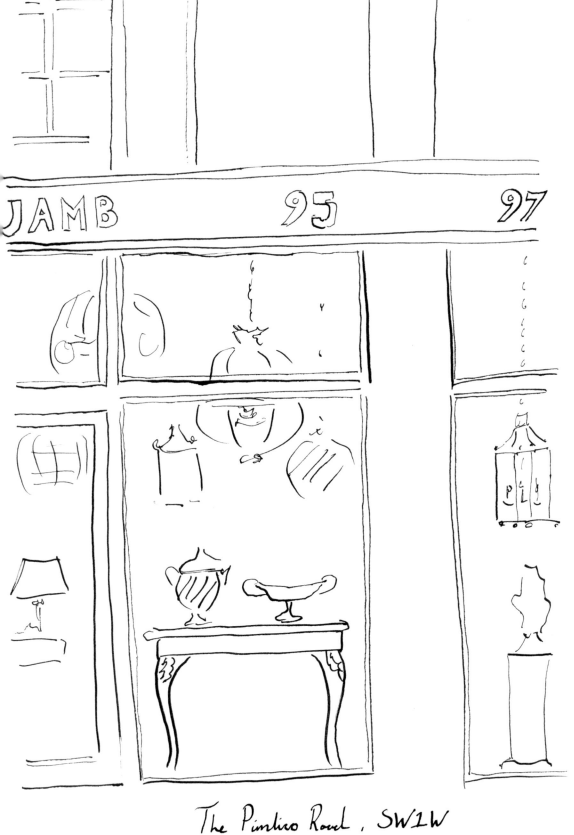

The Pimlico Road, SW1W

The question is –
will it fit?

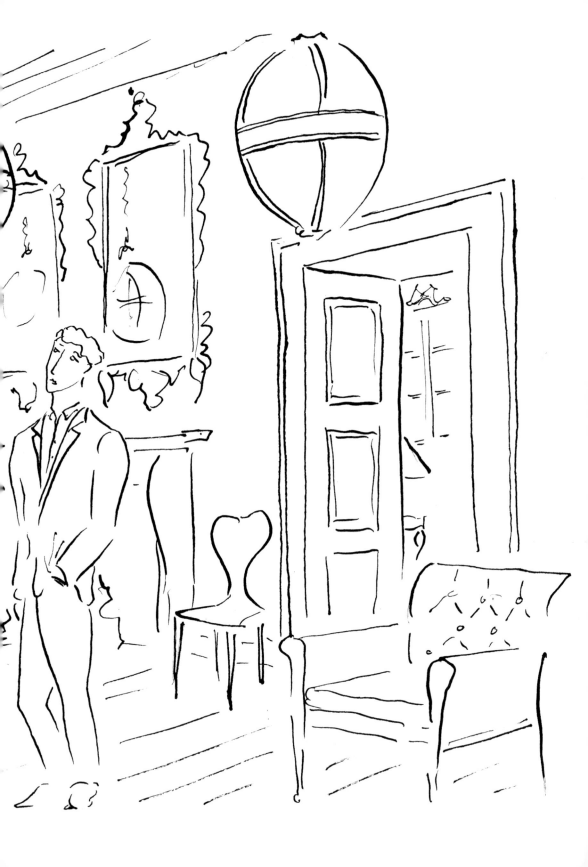

If you can't buy the title, you can always
 buy their sofa

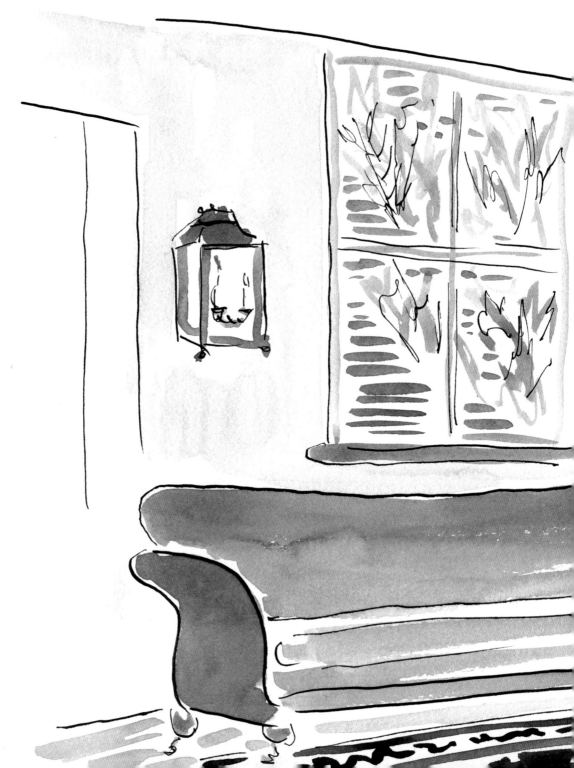

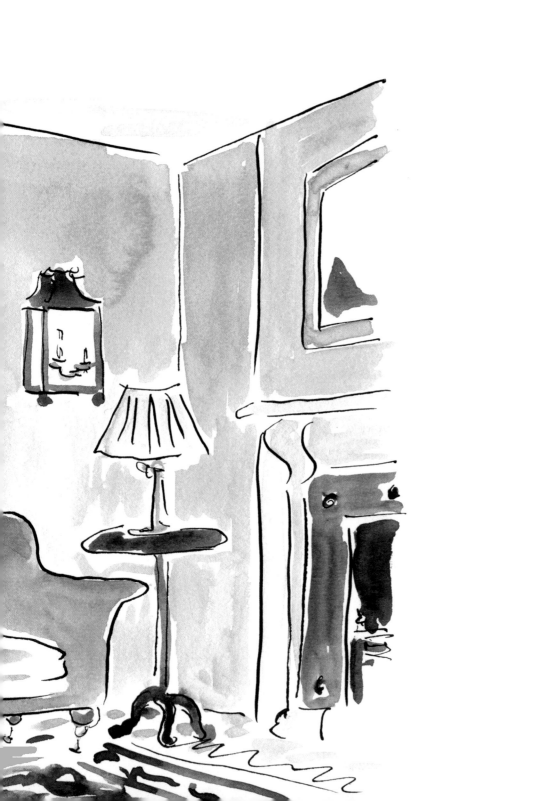

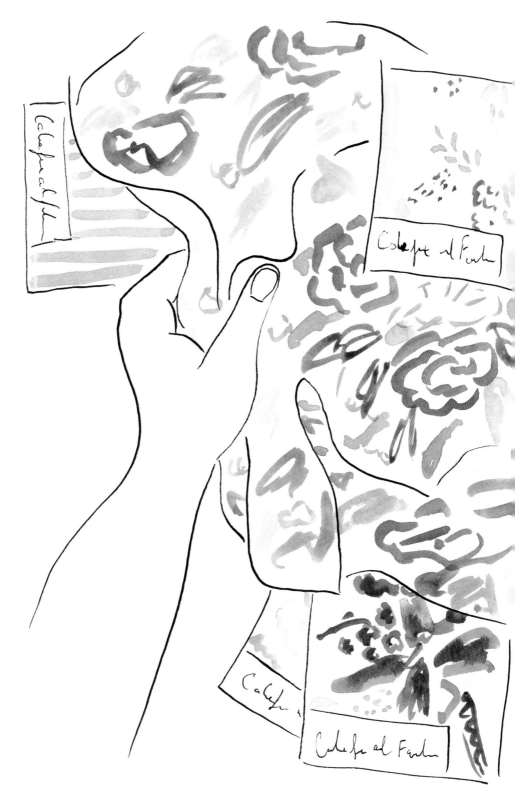

Men wear suits, windows wear chintz

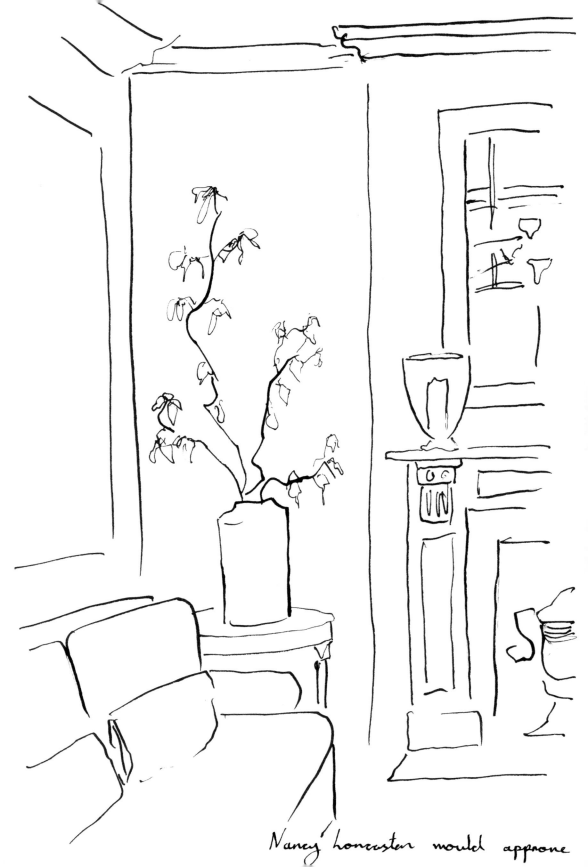

Nancy Loncaster mould approne

They were very forward thinking with the colours in 1907

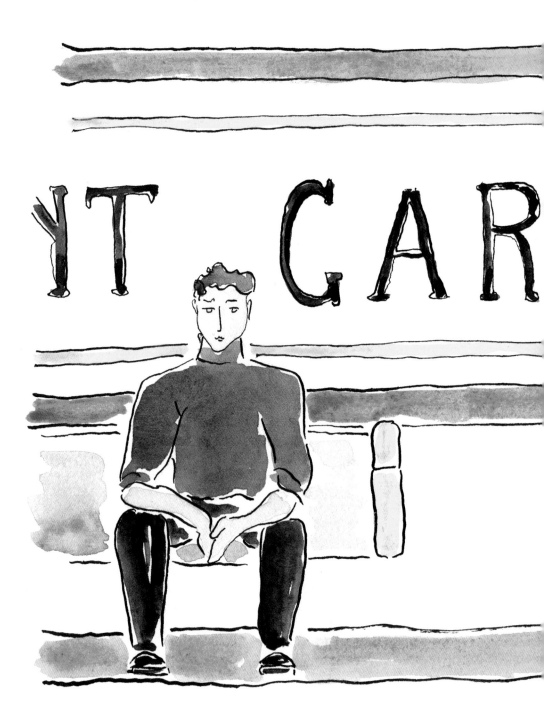

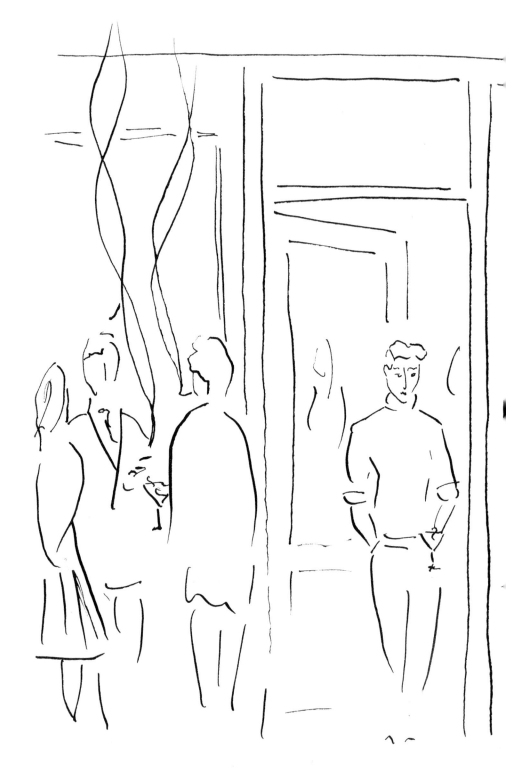

It's always the same crowd at these things

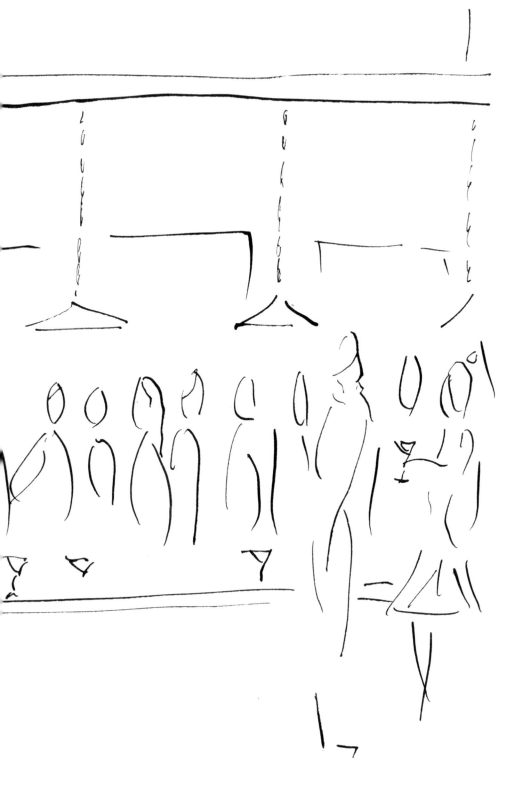

Thankfully the drinks were better than the art

He had the right idea

FRIDAY

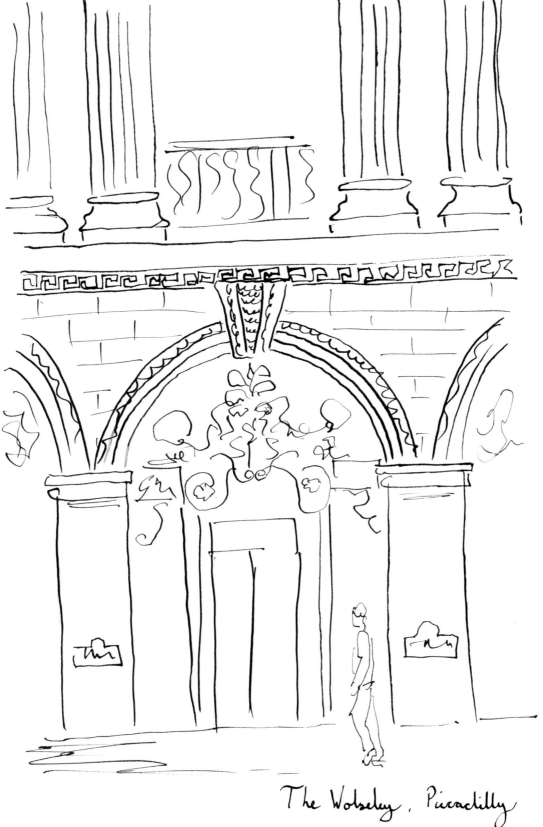

The Wolseley, Piccadilly

Why does having breakfast in the bar feel so illicit?

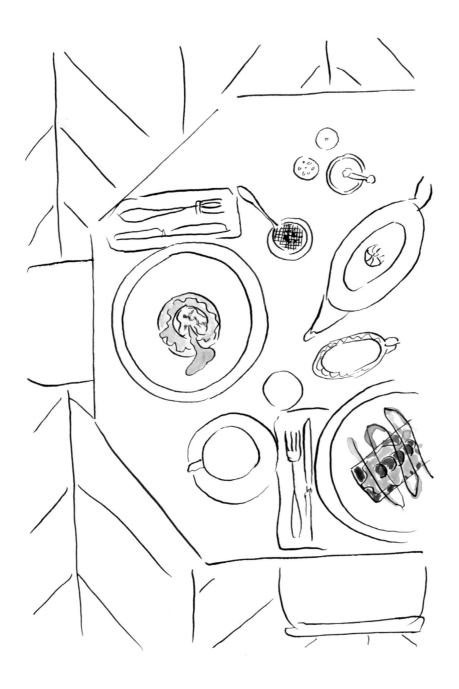

It's hard to find a better poached egg in London

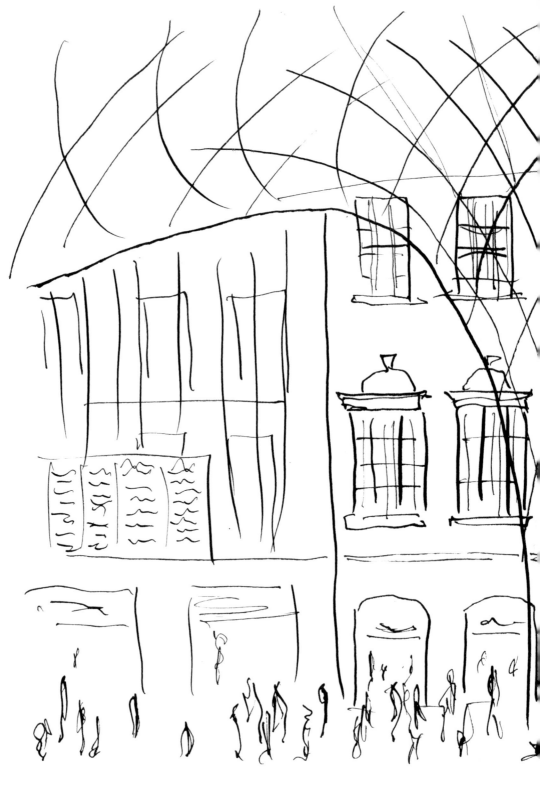

Collecting friends from Kings Cross

– I always think the architecture makes up for the crowds

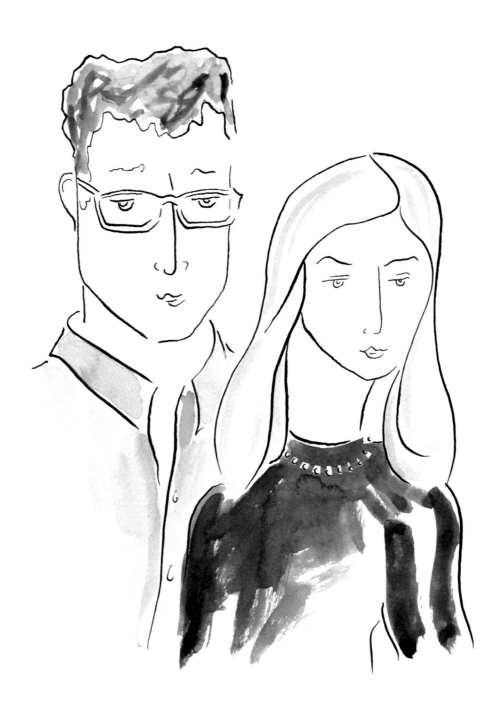

Childhood sweethearts; I'm always surprised they've lasted this long

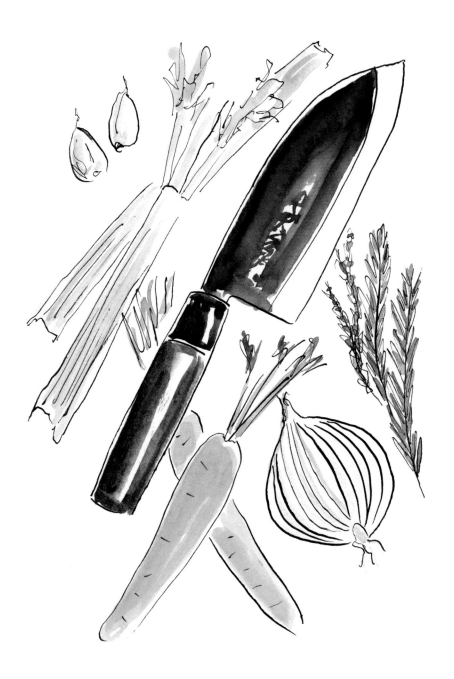

I'm sure the knife was designed to cut some
exotic fish, but it makes light work of
carrots

Cooking shouldn't be a spectator sport

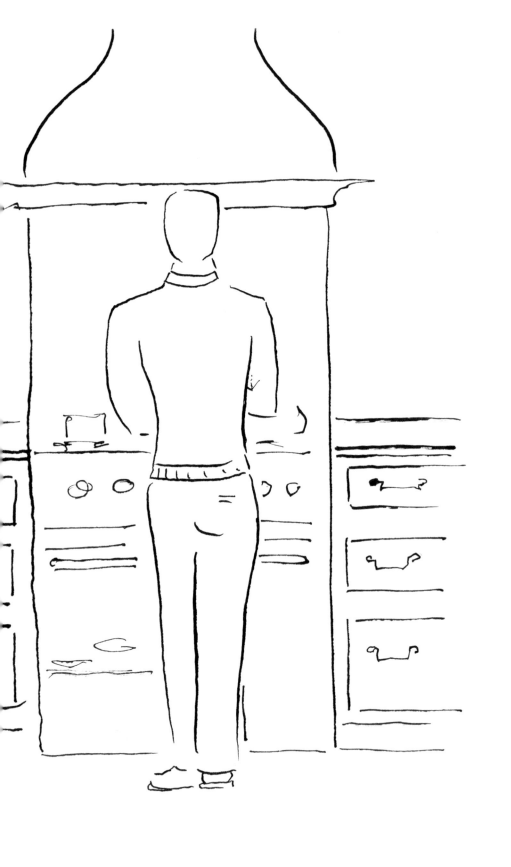

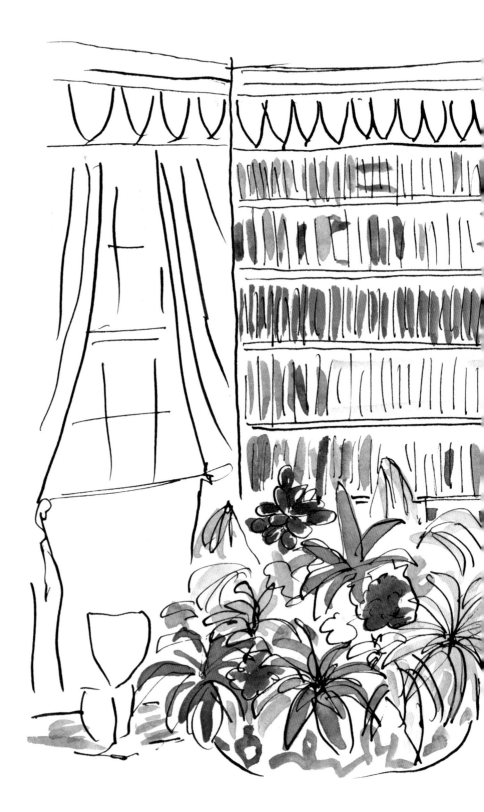

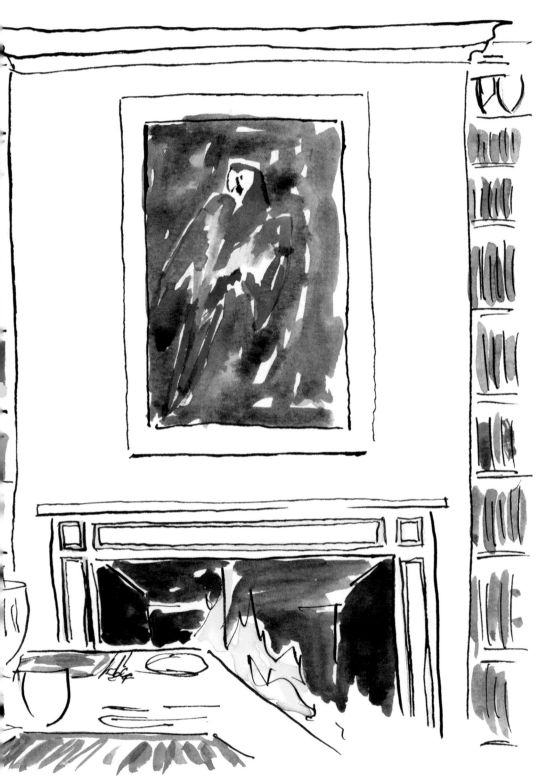

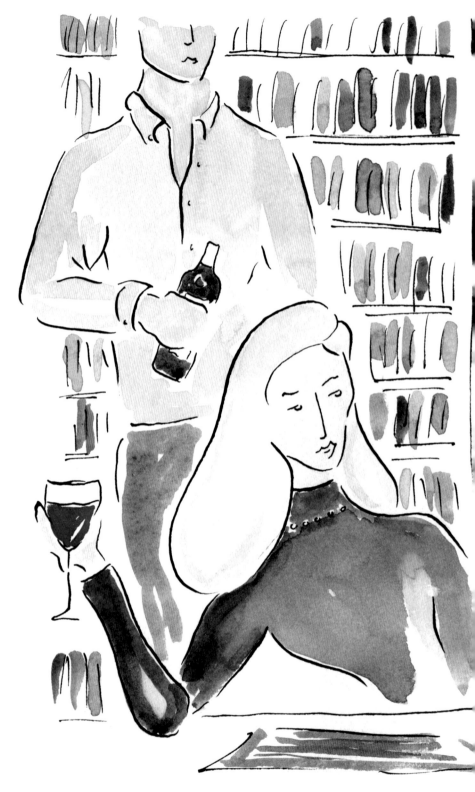

But first, food and fine wine

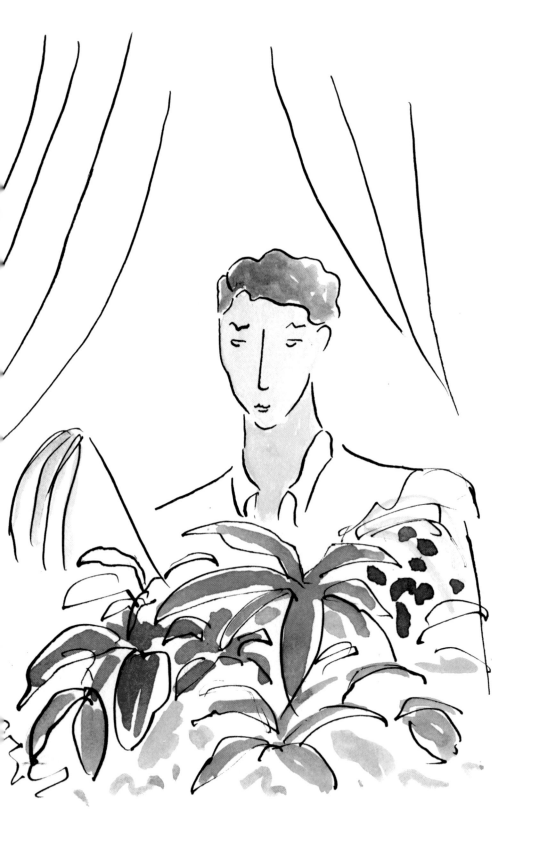

SATURDAY

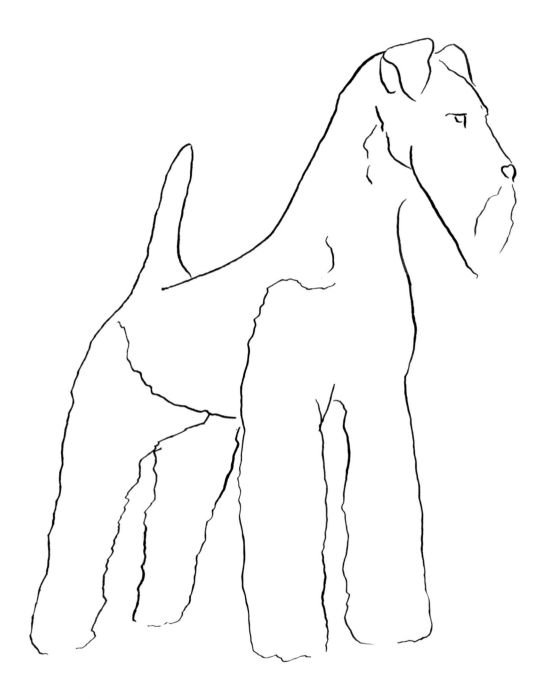

His Grandmother won Crufts don't you know

A walk in the park

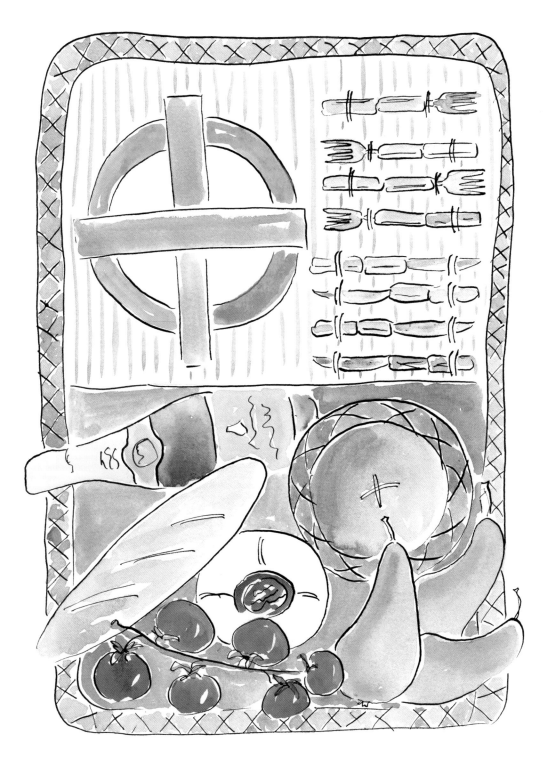

Picnics always seem like a good idea

What have you been up to?

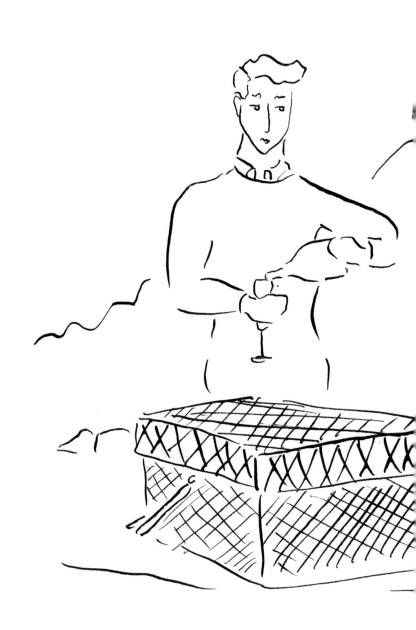

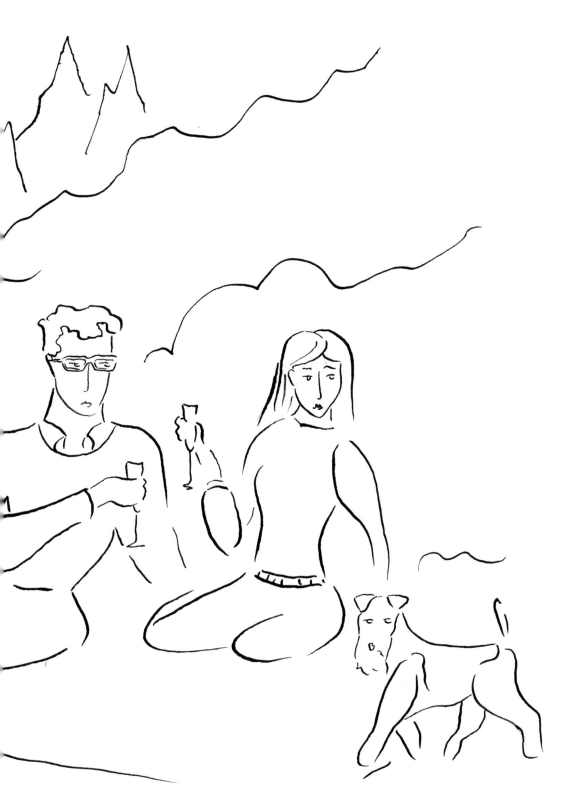

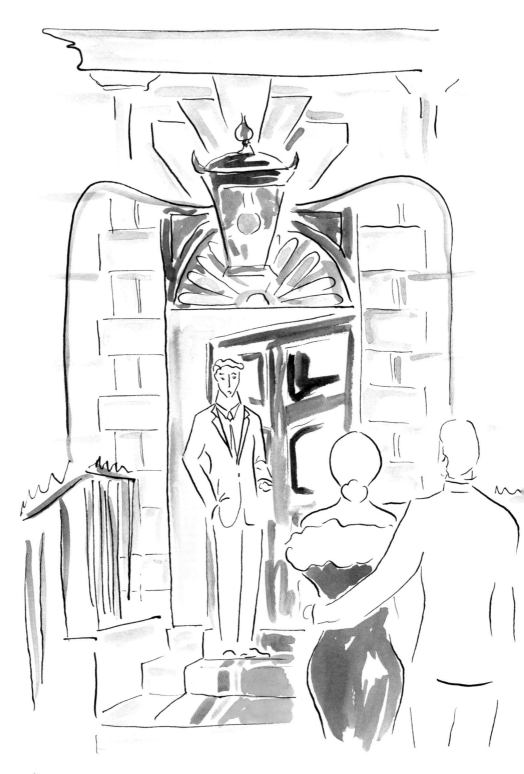

When in Mayfair ...

They say he's the best in Town

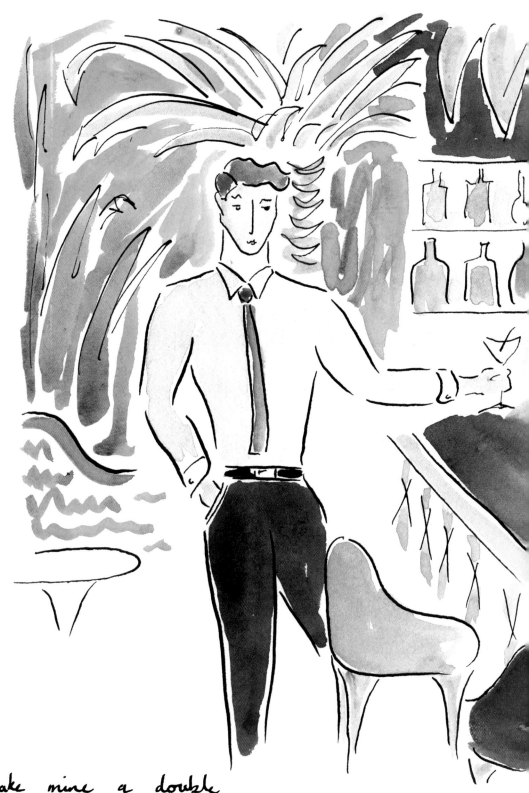

Make mine a double

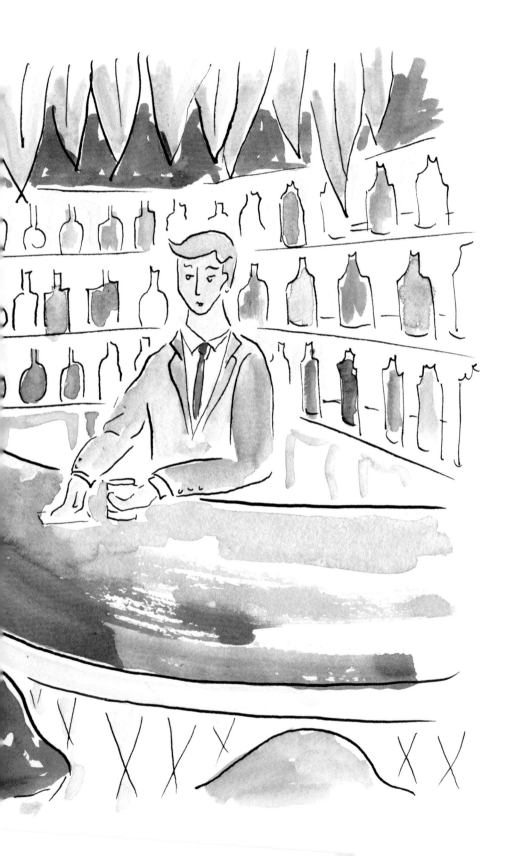

SUNDAY

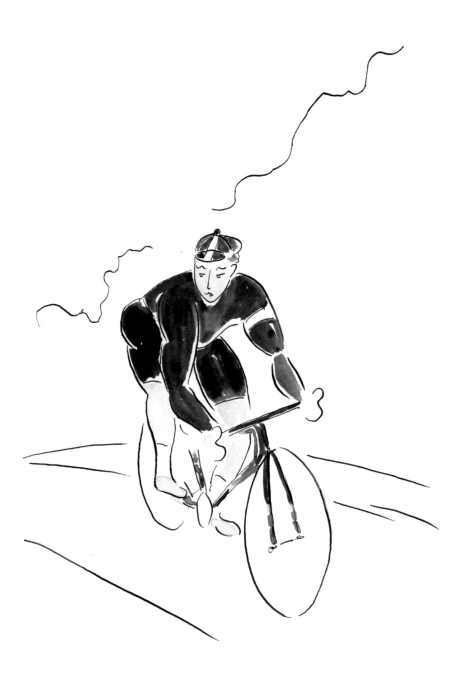

You can tell a lot about a cyclist by the length of his socks

A view of the city from Hempstd Heath

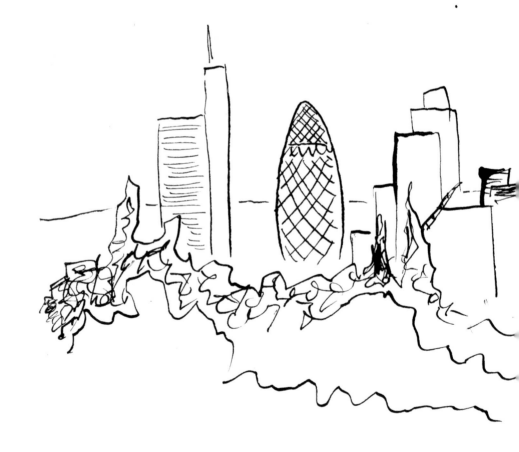

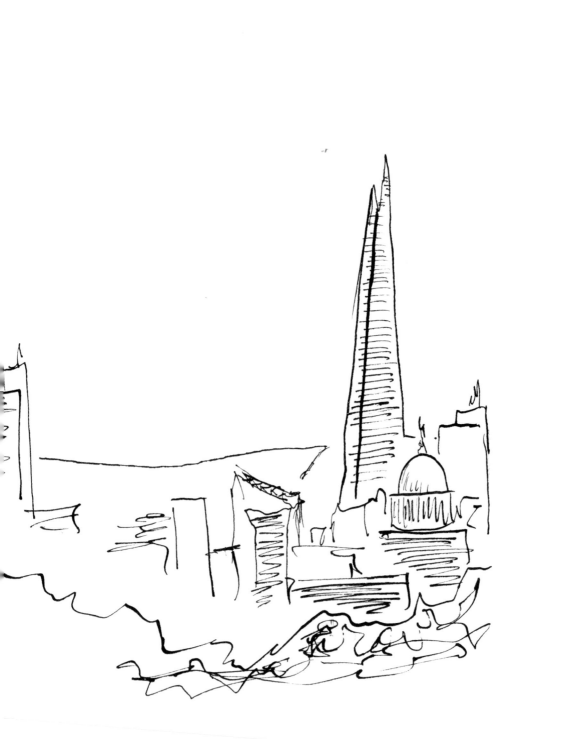

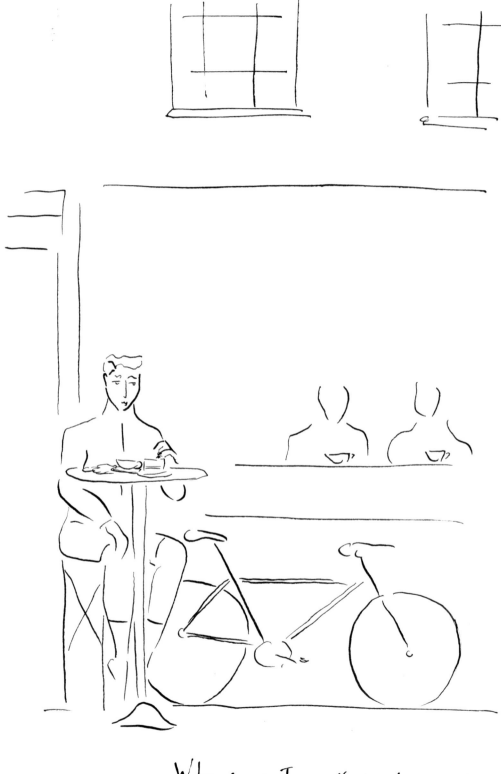

Who says I can't be hipster?

2.7 miles of cycling equals a large slice of Black Forest gateaux

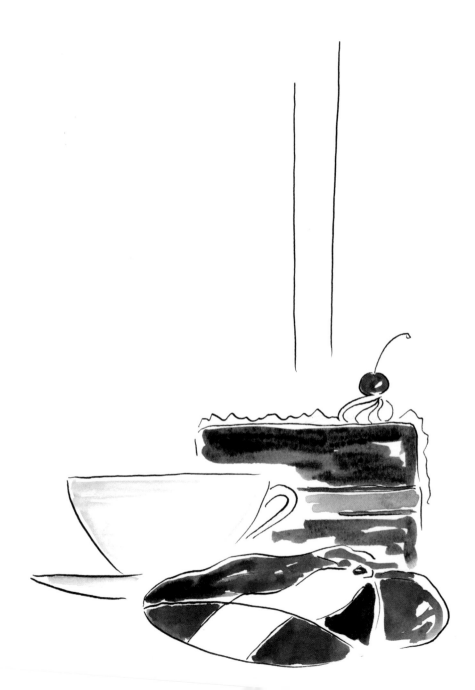

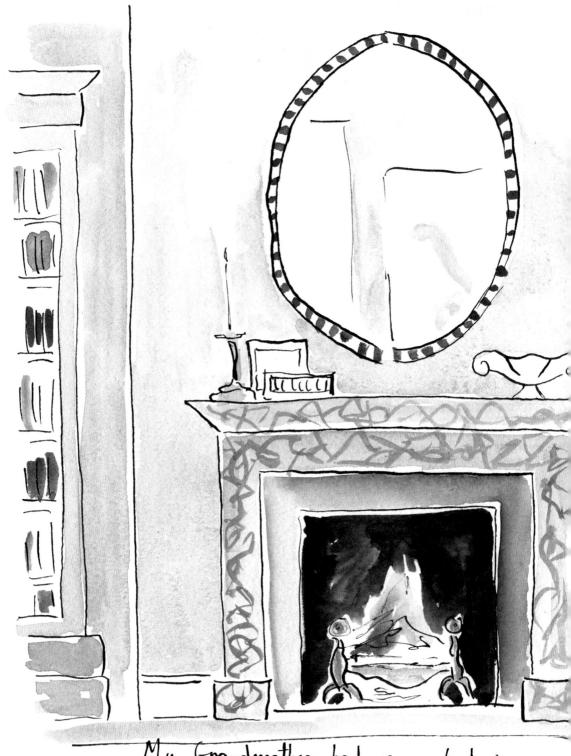

My Grandmother had poor taste in men,
but good taste in mirrors

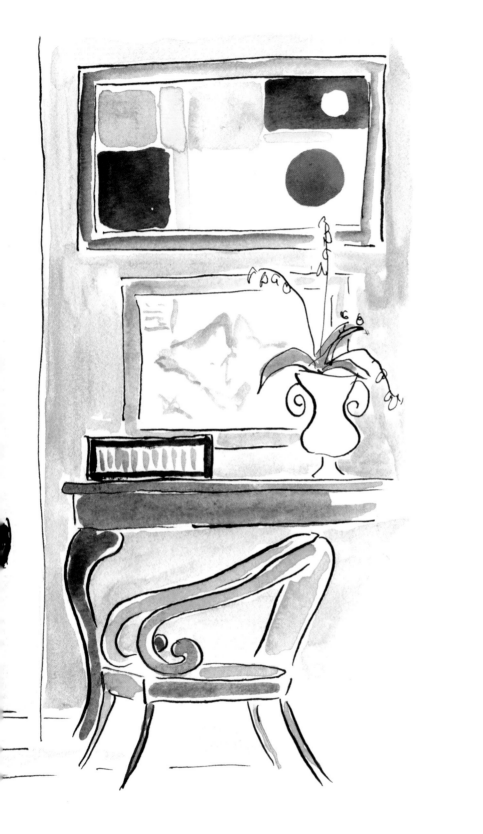

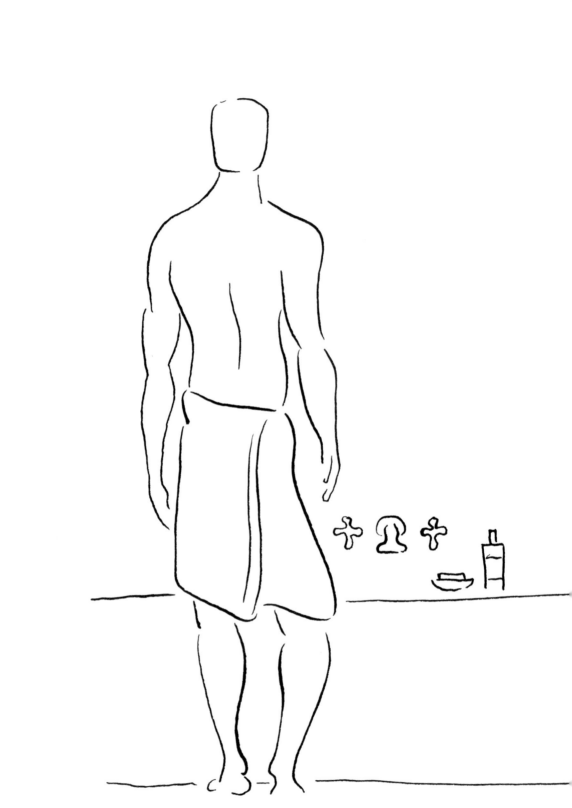

Bath time

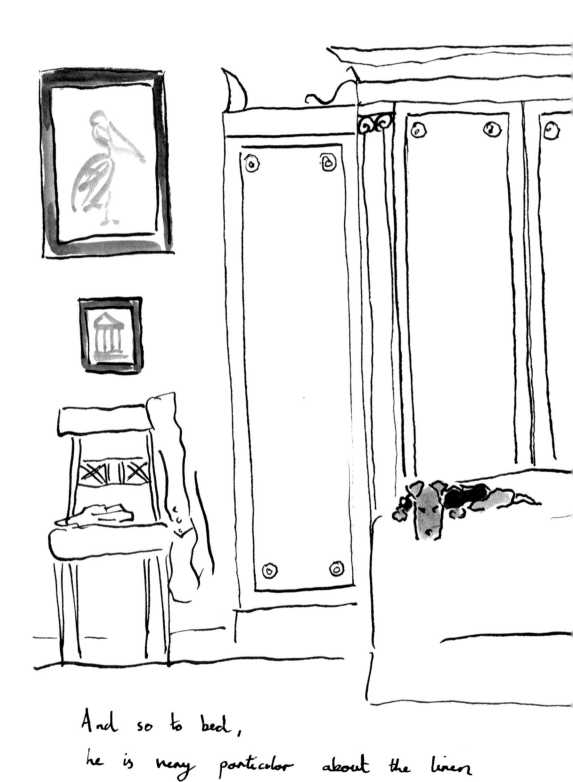

And so to bed,
he is very particular about the linen

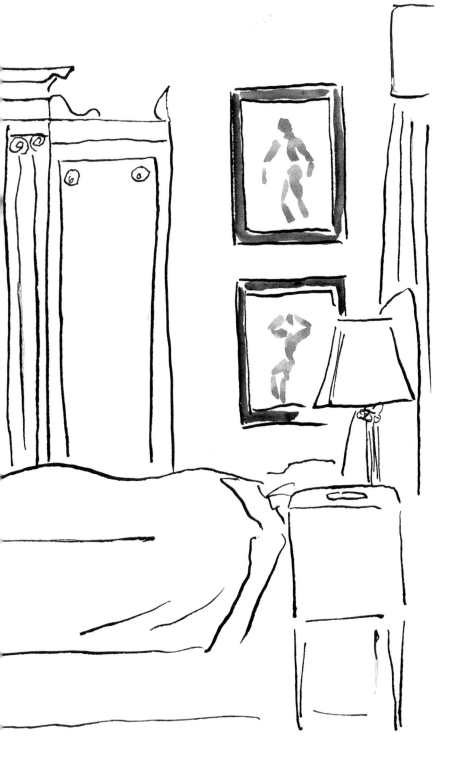

THE SKETCHBOOK
OF A GENTLEMAN

LONDON · ROBIN LUCAS

Published by New Heroes & Pioneers
Illustrations and text: Robin Lucas
Creative Direction: Francois Le Bled
Book Design: Daniel Zachrisson
Copy Editing: Matt Porter

Printed and bound by Lemon Print (Estonia)
Legal deposit October 2017
ISBN 978-91-98141-34-4

"Many thanks to all who have been involved with the book,
and all those who believe in me" – Robin Lucas

COLLECTIVE SHORTS
by NHP PUBLISHING